ESSAYS BY

PETER
SCHJELDAHL

LIZA LOU

& MARCIA
TUCKER

SMART ART PRESS, SANTA MONICA
IN ASSOCIATION WITH THE SANTA MONICA MUSEUM OF ART

© 1998 SMART ART PRESS
VOLUME IV, NO. 33

KITCHEN COURTESY OF EILEEN
AND PETER NORTON, Santa Monica

SMART ART PRESS
BERGAMOT STATION
2525 MICHIGAN AVENUE,
BUILDING C1
SANTA MONICA,
CALIFORNIA 90404
310 264 4678 (TEL)
310 264 4682 (FAX)
smartartpress.com

EDITOR: SUSAN MARTIN DESIGN: MICK HAGGERTY
PHOTOGRAPHY: AARON CHANG, ANTHONY CUNHA,
MICK HAGGERTY AND CARY OKAZAKI
PHOTOGRAPHY ASSISTANT: PETER REITZFELD
COPY EDITOR: SHERRI SCHOTTLAENDER

The collaborative spirit is the hallmark of Smart Art Press, and this book that presents Liza Lou's stunning KITCHEN and BACK YARD is no exception. Smart Art Press would like to thank the Santa Monica Museum of Art for bringing this project to our attention. For capturing the sublimity of Liza's work in words, we should like to thank Peter Schjeldahl and Marcia Tucker, and for dazzling us with his design, Mick Haggerty.

Distributed by D.A.P., 155 Avenue of the Americas,
New York, New York 10013. 1-800-338-BOOK

PRINTED AND
BOUND BY
JOMAGAR, S.A.
MADRID, SPAIN

SPLENDOR IN THE GRASS:
LIZA LOU AND THE CULTIVATION OF BEAUTY
PETER SCHJELDAHL 10

ADVENTURES IN LIZA LAND 46
MARCIA TUCKER

ACKNOWLEDGMENTS: 62
THE DIGNITY OF LABOR
LIZA LOU

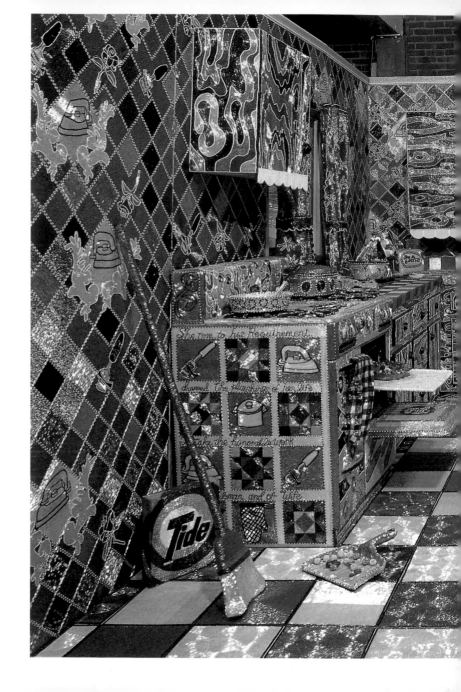

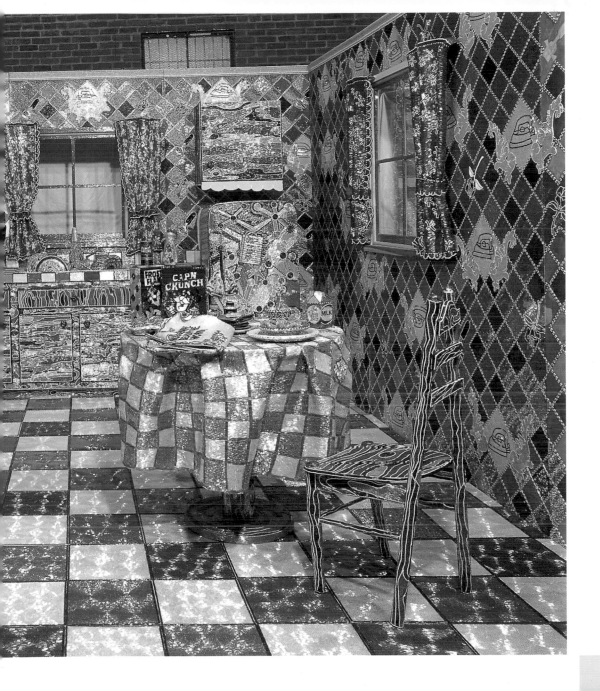

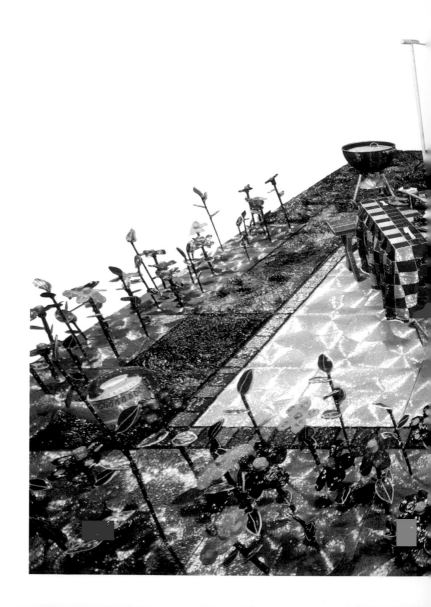

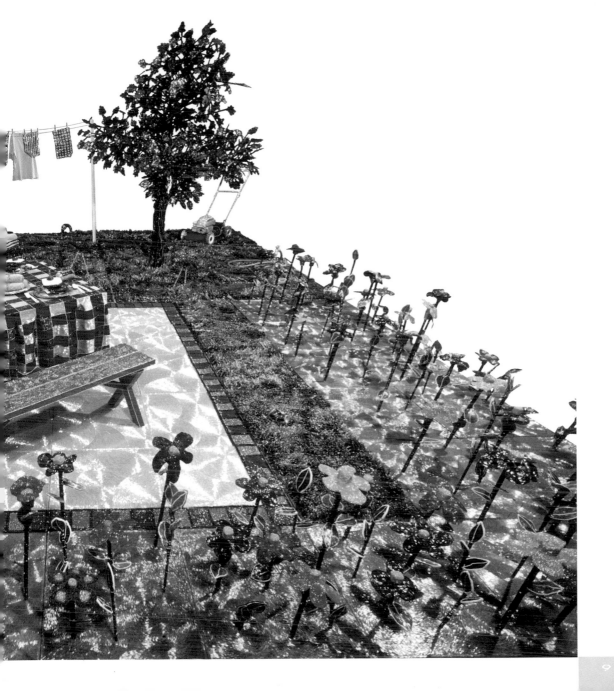

PETER SCHJELDAHL

SPLENDOR IN THE GRASS

LIZA LOU AND THE CULTIVATION OF BEAUTY

"I HATE THE WORD 'OBSESSIVE,'" LIZA LOU REMARKED

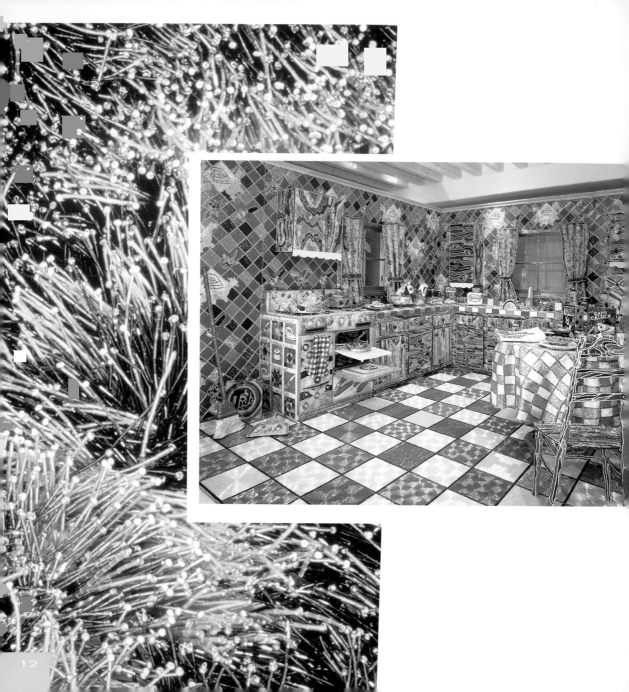

to me matter-of-factly. I was surprised. We had just met. Standing beside her, I was having my first look at the great KITCHEN, my gaze awash in glistening tides of reflected and refracted aureate light. I was entranced, "all eyes." You never see anything more acutely, while with less understanding, than the first time. Had I said something annoying to Lou? Or did she read my thoughts? My mind was indeed summoning memories and associations that, were they a computer file, could be tagged "obsessiveness." Chastened by her words, I stumbled inwardly. The KITCHEN blazed at me with new, alienated glory.

saw what she meant.

The KITCHEN is a sum of choices. It bristles with deliberation. Most of the decisions are clever, many are lyrically inspired, some are just goofy, and a few are abstruse, calling for explanations that, when provided, may not help much. Don't seek internal consistency, except of material: those multitudinous beads, tiny glass cylinders from the Czech Republic (long the world's bead-making superpower, a Czech friend assures me) glued in flabbergastingly variegated motifs and patterns. Procedures vary, forms vary wildly, and there is nothing like a governing style, let alone evidence of pathological predictability—the automatic pilot, the tic—which signals obsession. (Obsession is one damned thing over and over; the KITCHEN is one damned thing after another.) For unity, there is only a meltdown of sheer visual BLISS.

We are so eager to regard artists, often with well-meaning condescension, as nuts. We need them to be nuts, in a way. Otherwise we would envy and fear them too much. To appear at least neurotic (obsessive, fetishistic, regressive) can make make an artist beloved if combined with enough intelligence and charm to relieve the ghastly tedium of neurosis. (Being dead, like that unendurable man Vincent van Gogh, used to help, but today, what with protective screens of curators and journalists, it is not essential.) We smile at each other over the heads of artists as at the play of children. We employ another conventional image of the artist, too: the self-possessed professional whose dignity rests on proven earning power, among other hallowed American values. What we lack is a STORY between the two extremes— where the truth is and where Lou operates, navigating the art-cultural fog bank of the late 1990s.

The 1990s have seen the collapse of nearly all traditional rationales of art-making. Pity today's aspiring young artist, who confronts impossibly inflated and conflicting demands for effect—to resist and to rival popular culture, to advance political causes and to please crowds, to illustrate academic theory and to sell—while disoriented by the advanced decay of art's roots in craft disciplines.

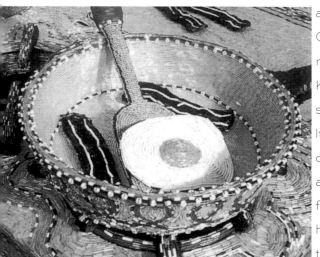

Our time gives the artist nowhere to start and nothing to master, then wants miracles. Lou's KITCHEN seems to me an anti-miracle, spectacularly refusing to fill any bill not its own. It is fundamentally hermetic, an armored refuge of personal initiative, though affected by such art-world pressures as the early-nineties fashion for social criticism. Somewhat hesitantly, meanwhile, the KITCHEN engages the one richly promising intuition that has been stirring in art of our time. I mean the intuition of beauty, which Lou will develop fully in her BACK YARD.

Beauty names the physiological standoff of attraction and reverence, appetite and awe, which stops us dead in our tracks before some object. With melting pleasure and intense satisfaction, we feel ourselves altered, or reorganized, in conformance to the object—thinking and feeling on the object's terms. The object can be almost anything, art or not art, and perhaps immaterial: even an idea, given only that it appears momentarily more powerful and valuable than oneself. Art used to court beauty as a lightning rod invites lightning. Then, in modern times, artists ever more readily sacrificed beauty to the pursuit of

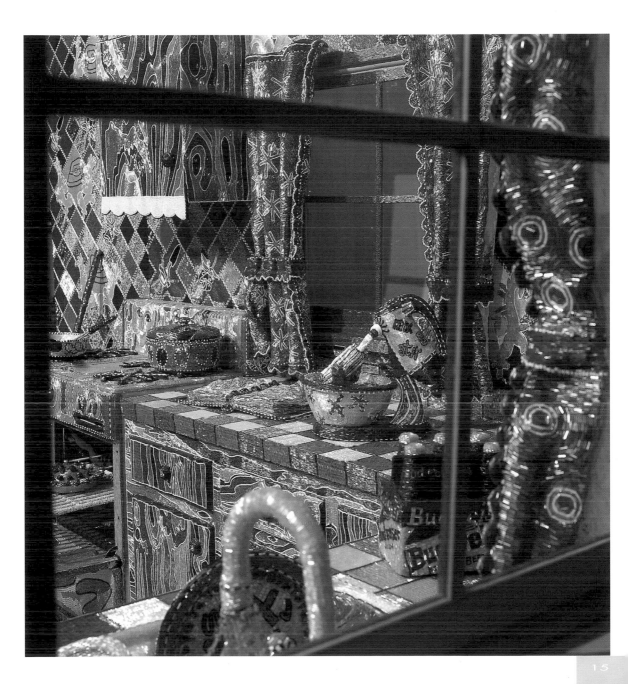

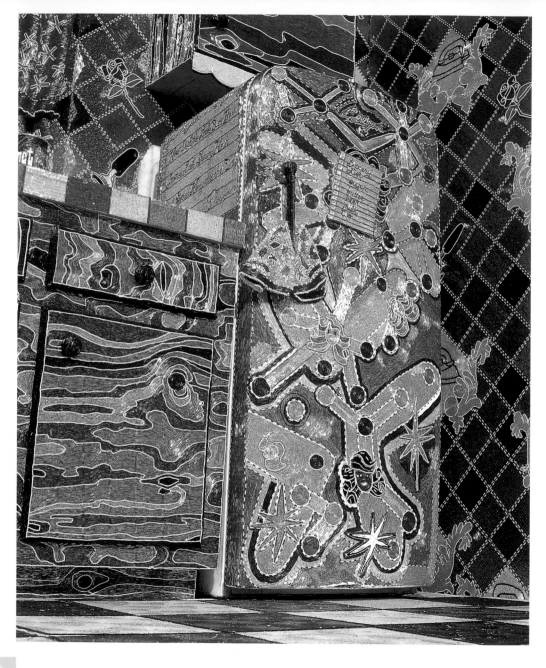

other aims and ambitions, opportunities and afflictions. It is a long story, ending in entropy—all the ingenious modern ideas of and for art piling up and spreading out, becoming interchangeable. Picking through the residue, artists try to recall a fundamental, difficult joy that art used to be about. There is nothing neat or clean in this transition.

"I hate the word 'obsessive'." And yet Lou's work can seem practically determined to be misunderstood as something friskily nutty, in one way, and righteously satirical, in another—exploiting an old, easy disdain for suburban ideals of domestic happiness, for instance. And nuttiness and satire really are present. Lou tacitly accepts a current role of the artist—the installation artist, in particular—as public entertainer. Call it the theme-park imperative: art as pocket Disneyland animating concepts unsuitable for prime time. If only in self-defense, Lou will play the clown. "I'm just a little gal from the avocado grove," she is apt to say, excusing herself from ponderous questions. Take it or leave it.

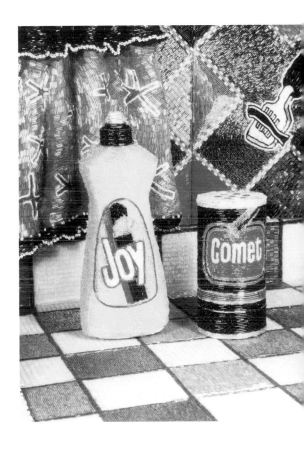

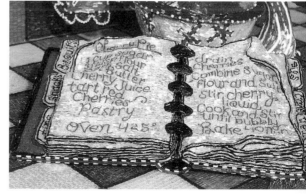

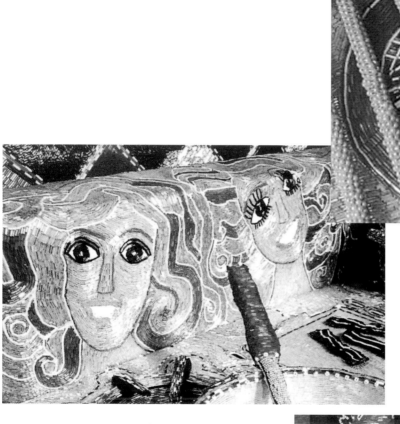

Meanwhile, Lou comes by her ambivalence toward suburbia honestly, from early experience in Minnesota and California. She is forthrightly feminist in familiar ways of valorizing "women's work" (the dainty, lumpen handicraft of decorative beading) and, at least in the KITCHEN, of calling attention to female stereotypes (note the girlie images in the oven). And she certainly does

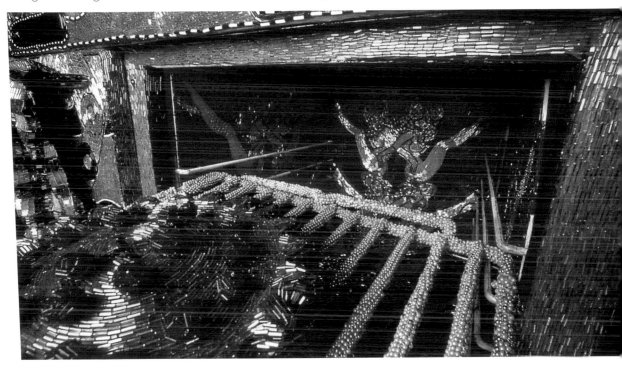

evoke obsession: the compulsive repetitions and horror vacuii of outsider art and the slavery to signs that merges people with their social description as, say, homemakers (never mind that the homemaker, like home itself, is a decrepit category today).

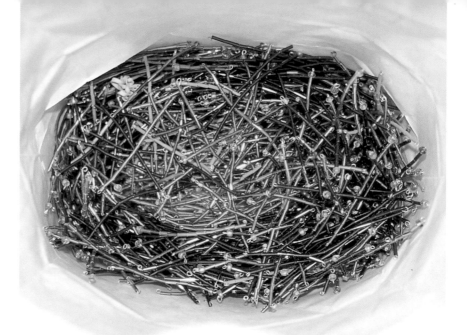

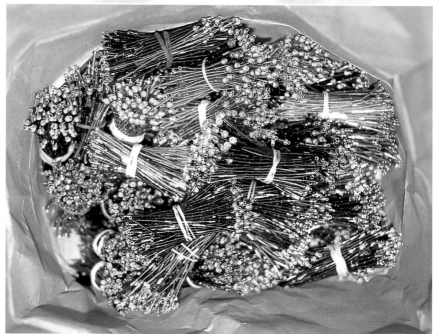

Then there is the collective labor that went into the BACK YARD. Many afternoon parties of volunteers gathered to produce blades of virtual grass for the piece's tousled lawn. (As the creator myself of twenty-one of the finest blades, I can tell you how it's done: With tiny pliers, crimp an end of a four-inch wire, slip on one round bead—a drop of dew, dig—and enough cylindrical beads to fill the wire, then crimp the other end. Presorted by Lou, your beads' colors occupy some part of a grassy spectrum from lush green to withered yellow.) This aspect of the work suggests a participation mystique or communitarian agenda like that of Christo's public-art circuses.

But all such apparent features of Lou's art—antic comedy, indignant satire, populist ceremony—seem to me mirages of her actual intention, which is simpler, more mysterious, and much less reassuring. The fearsomeness of the true artist's ruthless drive, to which we nervously apply patronizing epithets like "obsessive," rampages chez Lou. It does not spare the artist. In person she is serious, apolitical, and shy. Yet she makes art that is zany, polemical, and extroverted, against her own grain, with grueling techniques that have given her painful tendonitis in her hands. Is she confused? No. What would be contradiction in logic is only complexity in successful art.

Admittedly, the complexities of the KITCHEN (unlike the radiantly integrated BACK YARD) can seem only too numerous, getting in each other's way. But this should not stop it from being a classic of our time. Nor is it at all surprising. Here is an artwork that consumed five formative years of a young artist's career. Developments and changes that might have been worked out over scores or hundreds of separate pieces accumulated within one piece. Lou

made the KITCHEN up as she went along, she has said, and it stands to reason that the artist who began it and the artist who completed it were not the same person. It survives as a palimpsest of ideas, events, and states of mind lost to present time—growing in importance as, in her subsequent work, Lou applies the lessons she learned from it.

Consider the KITCHEN's most enigmatic element, the newspaper that bears, besides the buoyant headline **"HOUSEWIFE BEADS THE WORLD!,"** the teaser **"PLUS! FROGMAN REVEALS THE SECRETS OF TOUGH LOVE!"** The Frogman, Lou has told me without naming a name, was a teacher at the San Francisco Art Institute who denigrated the KITCHEN in its early stages. The assault hurt, and to even sarcastically term it "tough love," suggesting a benign motive, seems pretty mild revenge. At any rate, it seems that, to go on with the work, Lou had to assimilate that moment of anguish. So in went the Frogman, despite his puzzling disruption of a viewer's reverie.

Besides incorporating different faces of Lou, the KITCHEN plays host to guest subject-ivities. These range from the collective frozen attitudes of product packaging and

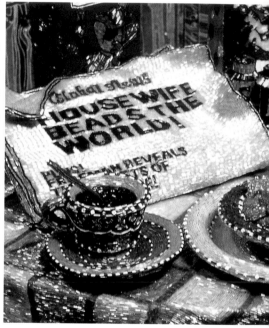

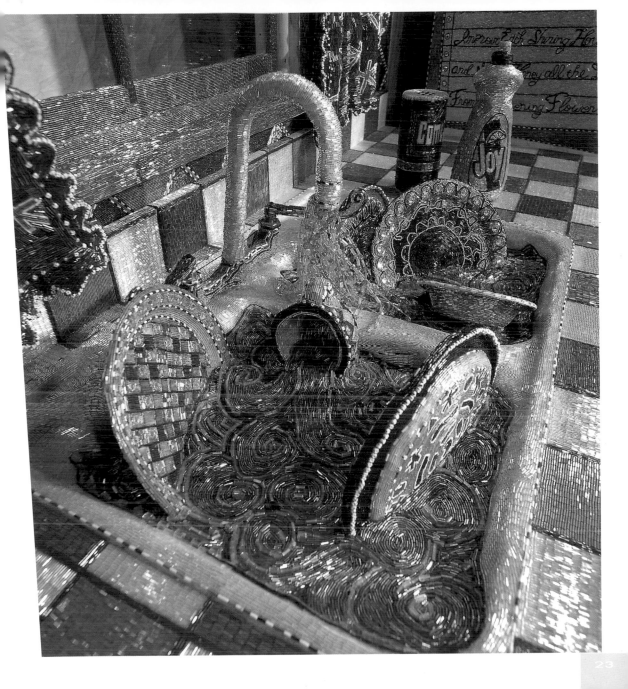

Improve Each Shining Ho[ur]

and [M]oney all the

From [evening to mo]rning Flower[s]

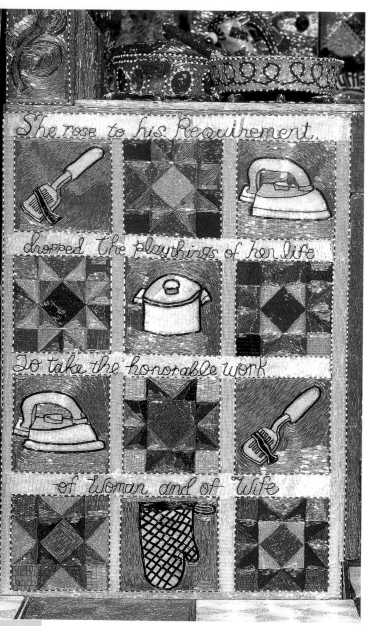

vernacular design and decor through intervening symbolism (black wallpaper roses for death) to heartfelt stylistic allusions (van Gogh's STARRY NIGHT in swirling dishwater) and haunting sentiments of Emily Dickinson. Here is the Dickinson poem that the KITCHEN quotes:

She rose to his requirements, dropped
The playthings of her life
To take the honorable work
Of woman and of wife.

If aught she missed in her new day
Of amplitude, or awe,
Or first prospective, or the gold
In using wore away,

It lay unmentioned, as the sea
Develops pearl and weed,
But only to himself is known
The fathoms they abide.

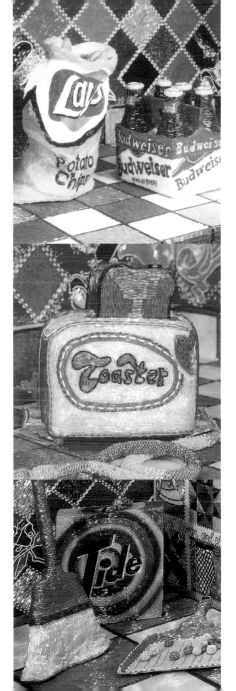

This beautiful poem envisions the self as a sea. The married woman who is the poem's subject presents on her surface "the honorable work" (note the poet's choice of flat, officious language) "of woman and of wife," to which she "rose" from her depths. What goes on in those depths now? The never-married poet wonders but, with transcendent moral grace, declines to speculate or judge. Only the sea itself can locate the precious "pearl" and noxious "weed" that it nurtures. A viewer of the KITCHEN is accordingly alerted to mysteries beneath its cheeky, jazzy scintillation. If you think you can make out the artist's opinion of housewifery, in other words, you are projecting. Stop it.

The KITCHEN is ungraspable in its wholeness, like the Mississippi River delta. It ramifies the artist's mind into numberless byways that disgorge unevenly into a viewer's consciousness. Contemplating it, one picks up on this or that aspect or element, then drops it to pick up on another. In comparison, the

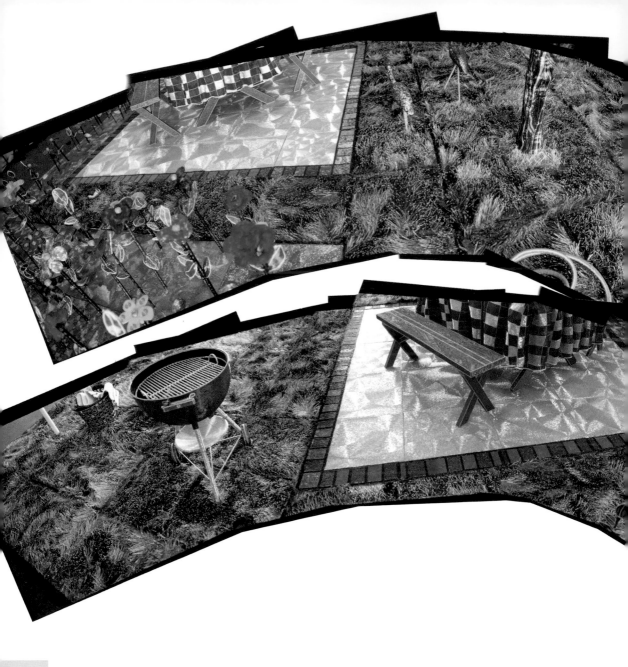

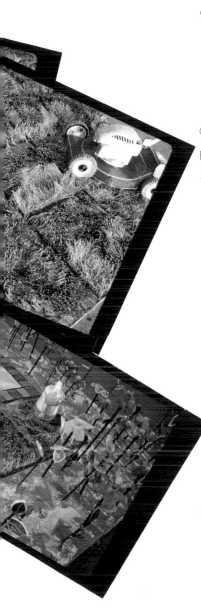

BACK YARD is more like the mouth of the Amazon, draining a continent's maze of tributaries into one mighty surge. Though writing before the BACK YARD's final completion, I have seen enough to be confident that, beholding it, one cannot isolate any detail from the torrential, overwhelming unity to which it belongs. Of course, part of what's overwhelming about the BACK YARD is our simple awareness of the incredible toil that went into the thing. But this is only a temporary frisson, I think, because the toil proves so obviously indispensable to the work's success. To enjoy the BACK YARD, once its initial shock wears off, is to approve Lou's exertions as sensible. Obsession has nothing to do with it. Did the Sistine ceiling "obsess" Michelangelo? It absorbed him, certainly, in the way of any labor-intensive task. Most human existences are largely given over to toil, but in motions that leave either no trace or discontinuous traces. Our working lives flow or tumble into forgetfulness. In the case of the BACK YARD, nearly every instant of Lou's recent working life happens to register at once, with a bang.

The BACK YARD is a work about work whose theme—and here comes its lovely, transcending humor—is the foremost American ideal of leisure. If the unfenced, uniform lawn of American frontyards declares democratic discipline (here I draw on a great book of

gardening philosophy, Michael Pollan's SECOND NATURE), the modular playpens of American backyards express democratic fulfillment. The BACK YARD endorses a nation whose citizens of widely differing incomes all sincerely deem themselves "middle class." The dispossessed poor and the estated rich (THE GRAPES OF WRATH, THE GREAT GATSBY) pose chronic problems for American identity. And those of us who inhabit apartments give rise, even in our own souls, to chronic ambiguities. To be an honest-to-goodness American, have a backyard and get a kick out of it, end of story.

The kick of Lou's BACK YARD is over the top. Surreal excrescence bursts forth everywhere. Mildly pleasurable things, inflecting an order dedicated to mild pleasure, break sweats of ecstasy. Get a load of those flowers! In a standard backyard, you know that they would be cheerful banalities of impatiens and anemones. Here some Alice in Wonderland compost has made them apparitions of no known species. At once quiveringly erect and open, they are hermaphroditic sex organs verging on orgasm. And yet we understand that they are only flowers in an American backyard. Pretty things, yes? Nice things.

To cook food on one's own grill and consume it with a few beers at one's own picnic table, surrounded by nature regimented according to a plan so unquestioned that it might as well be God-given: American bliss. Can you disdain it? I can't. It really is nice. Regrettable may be only the concerted lack of imagination intrinsic to a vision of happiness as absolute predictability: no surprises. But the adventures of art and the ritual of backyards are not in some zero-sum competition with each other. One life can accomodate both, just not in the same place and time—except where and when Lou takes a hand.

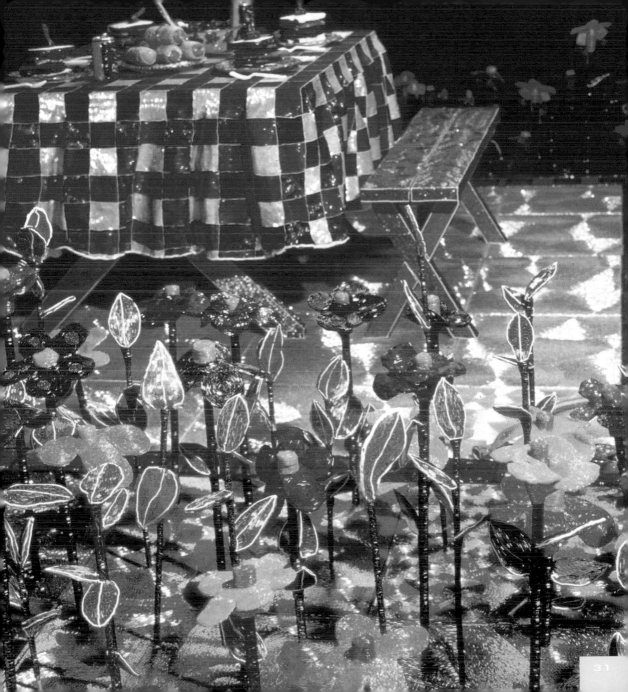

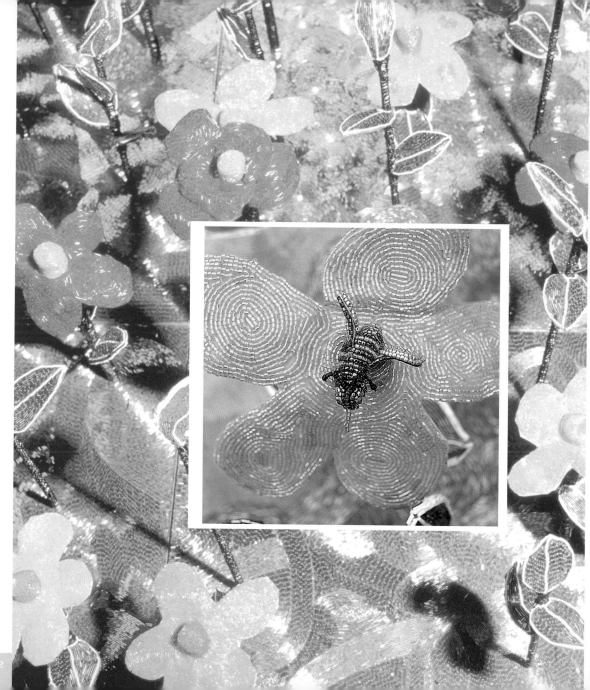

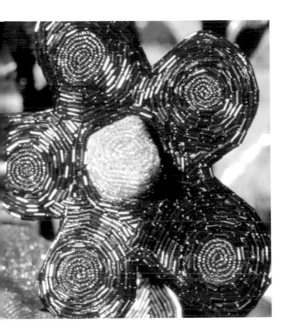

The BACK YARD is a steady-state hallucination. It is about peak consciousness, when awareness dilates to its maximum degree—in religious practice, in beauty, or with drugs, no matter. Lou's crystallized rapture doesn't recommend anything to us. It doesn't even recommend itself as necessarily a good thing. On a sheerly empirical plane beyond good and bad, the BACK YARD is matter-of-fact, like the artist. "This happens," it says, if it says anything. "Such splendor actually occurs—is actually occurring at this moment—and you should make what you want of it. Or not. Such splendor has made itself available to you, and it doesn't care."

Lou's inspired choice of a ubiquitous, humble subject for the magnificent frozen hosanna of this work fulfills Charles Baudelaire's definition of beauty as a fusion of the eternal and the fleeting, the exalted and the everyday, heaven and hell, the sacred and the profane, reason and squalor. Its effect is the opposite of obsession: liberation from closed circuits of the self, prying us open to pure wonder. It brings about a high holy day of the mind, when things always obscurely true stand revealed, clothed only in the lucid radiance of the self-evident. I have many feelings about Lou's achievement. The main one is gratitude.

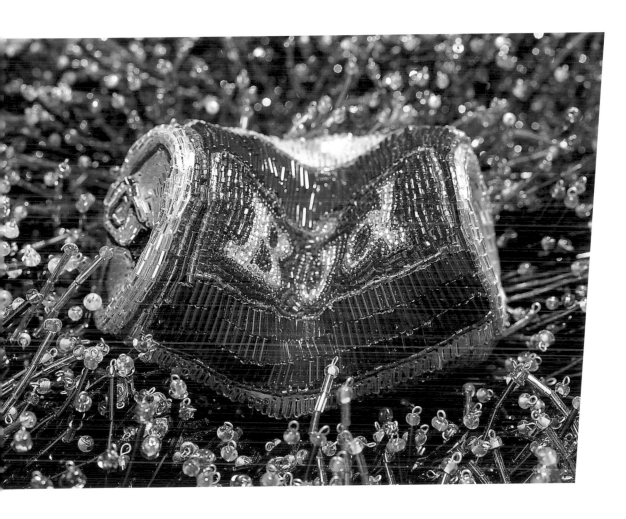

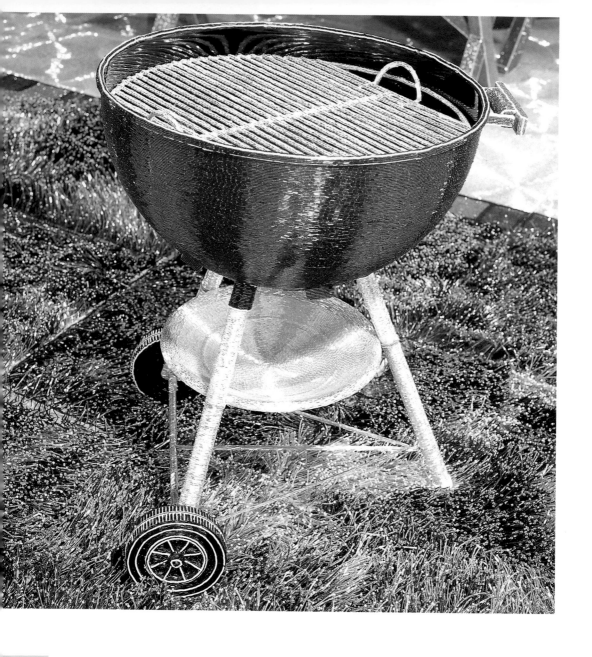

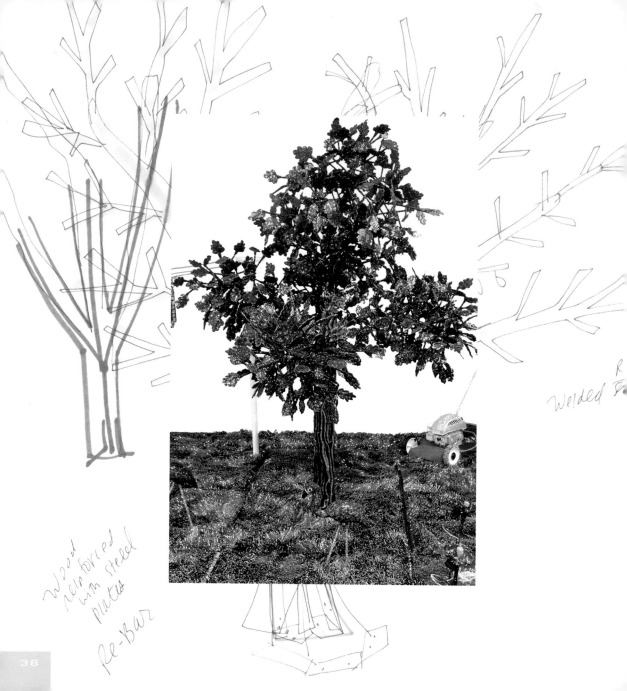

Welded R B

Wood Reinforced with steel plates

Re-Bar

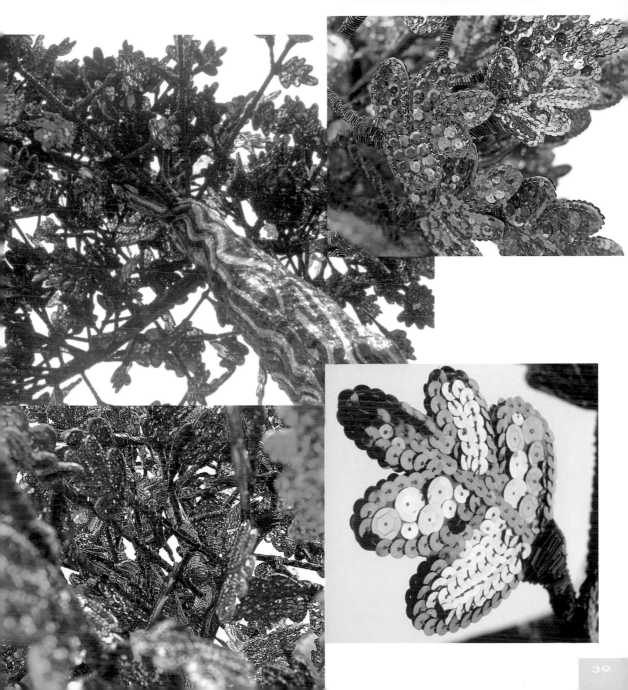

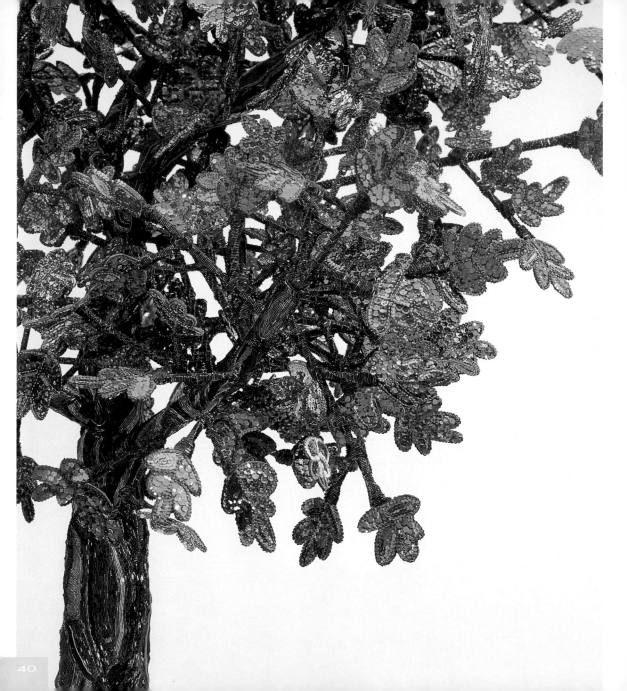

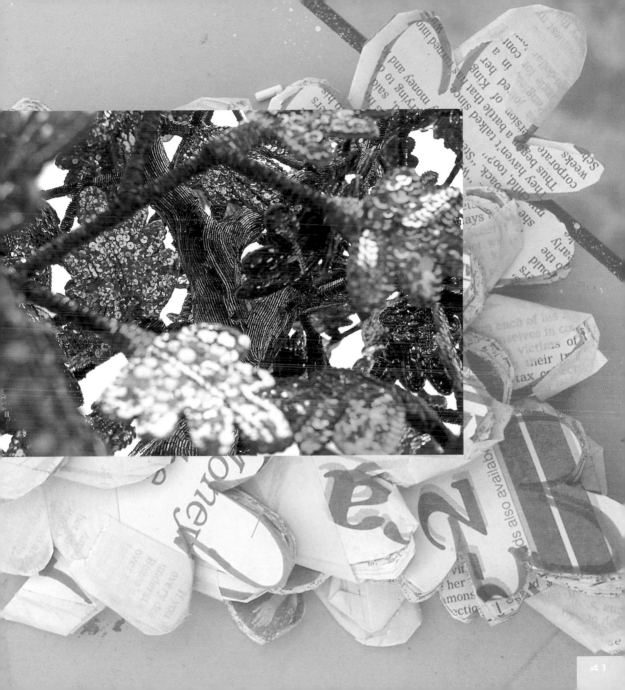

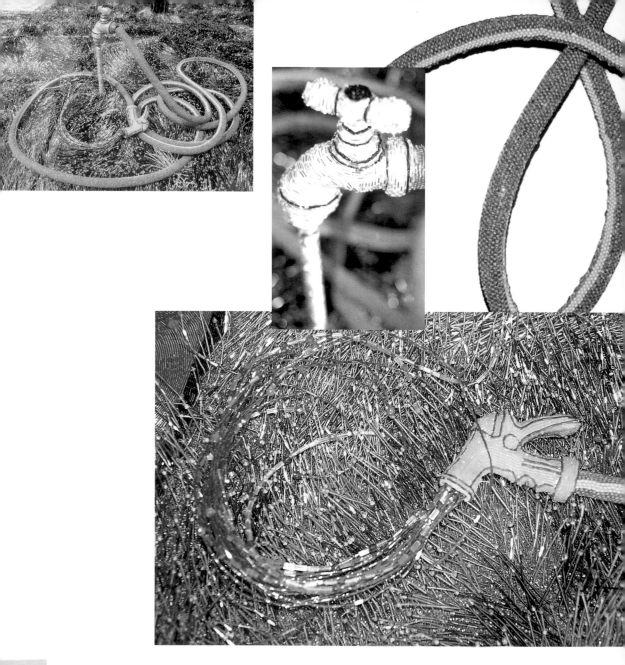

MARCIA TUCKER

"ART WHICH USES THE EVERYDAY AS A SOURCE OF RESISTANCE AND INSPIRATION, WHICH CONSTANTLY RETURNS TO VIEWERS A SENSE OF THEIR OWN ABILITY, CREATIVITY, AND IMAGINATIVE POTENTIAL, MAY BE FORCED TO OPERATE AT THE BOUNDARIES OF ARTISTIC DISCOURSE, BUT REMAINS CENTRAL TO THE DISCOURSES OF LIVED REALITY."[1]

SEEING LIZA LOU'S KITCHEN AND BACK YARD FOR THE

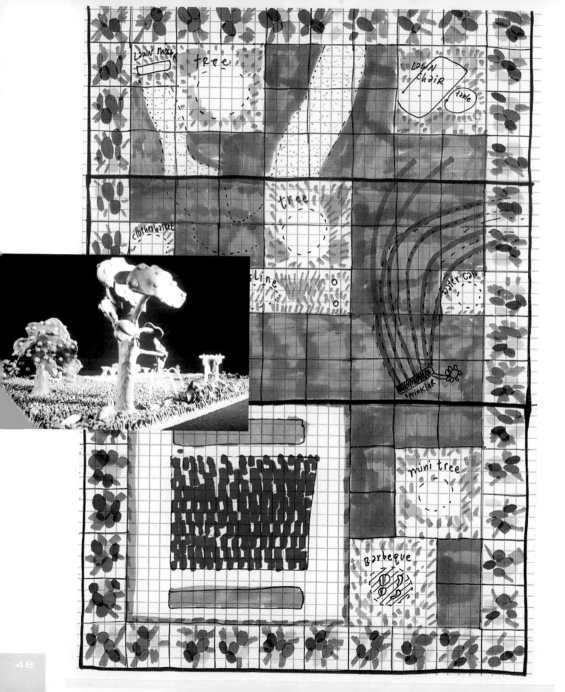

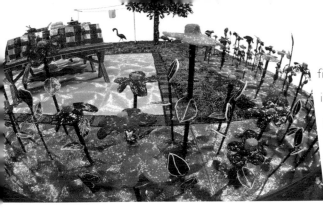

first time is like plummeting headlong into the visual and spatial adventures of a modern-day Alice in Wonderland. It's virtually impossible not to be astounded and captivated by the magical transformation of familiar environments and objects she's presented. Grounded in the ordinary, Liza Lou's beaded world is spectacular and delightful, full of wondrous and unexpected juxtapositions and ripe with deliciously subversive details.

Often a viewer's first response to the work is followed by something like "Where on earth did she find the time to do all this?" Many people have commented that the work belongs in Ripley's "Believe It or Not" or THE GUINNESS BOOK OF WORLD RECORDS for its sheer labor-intensiveness. After all, it took an ungodly amount of time to do, the labor is of Liza's own choosing, and it was almost entirely done by her own hand. (She has recently held a series of public "lawn parties" to help make the hundreds of thousands of blades of grass for the BACK YARD, at once an act of generosity and an homage to the engaging and democratic nature of participatory public art projects.)

When a work requires this much work, both the nature of time and the value of production in relation to it are made visible: thus Liza Lou's chef d'oeuvre gives substance to the old saw that "time is work and work time." In this combined piece, the sense of time is extravagantly attenuated, not only because the repetitive and meditative nature of beading, especially on such a grand scale, slows things down, but also because the nature of polychronic (nonlinear, multitasked) time encourages shared and social rather than linear or goal-oriented activities.

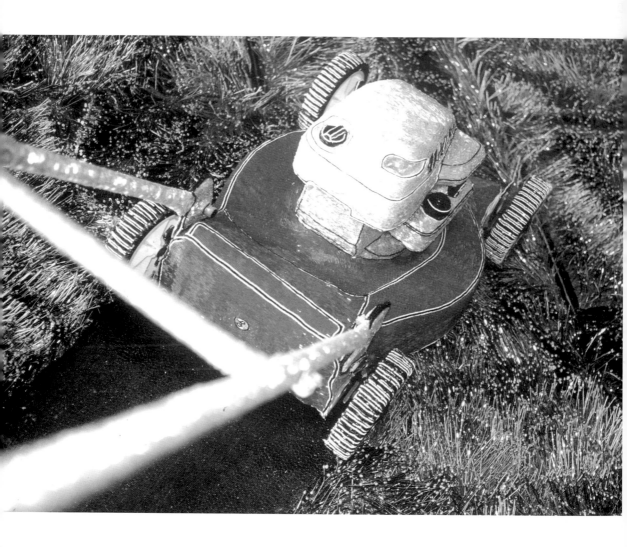

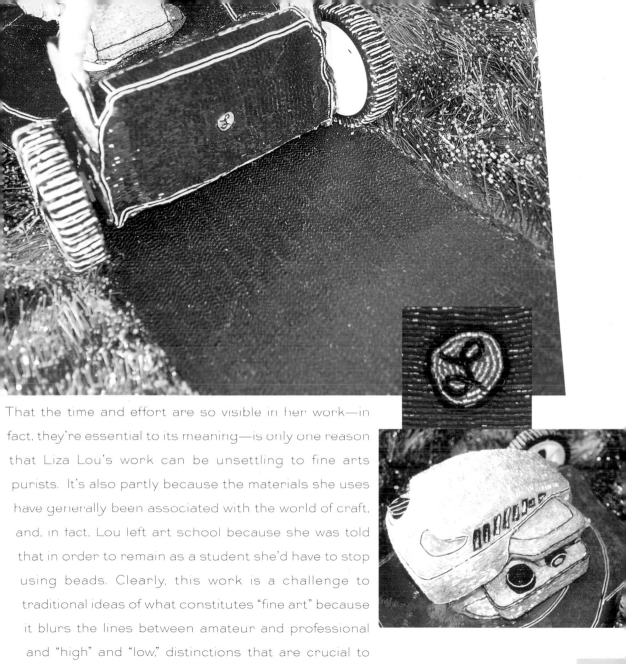

That the time and effort are so visible in her work—in fact, they're essential to its meaning—is only one reason that Liza Lou's work can be unsettling to fine arts purists. It's also partly because the materials she uses have generally been associated with the world of craft, and, in fact, Lou left art school because she was told that in order to remain as a student she'd have to stop using beads. Clearly, this work is a challenge to traditional ideas of what constitutes "fine art" because it blurs the lines between amateur and professional and "high" and "low," distinctions that are crucial to

those who maintain a highly restrictive and elitist definition of
artists and artworks.

For die-hard modernists, tackling even the most complex issues
through humor, playfulness, or even seduction just doesn't cut
the mustard. This kind of criticism is, unfortunately, fairly
common. As the writer Howard Becker points out, "Art worlds
typically devote considerable attention to trying to decide
what is and isn't art, what is and isn't their kind of art, and who

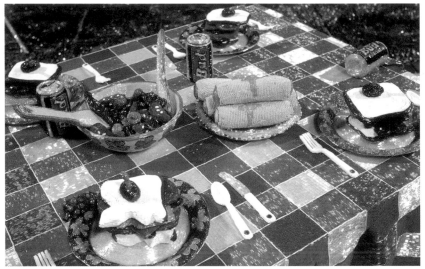

is and isn't an artist. . . . Furthermore, art worlds provoke
some of their members to create innovations they then
will not accept."[2]

Be that as it may, I still can't recall any other single
contemporary art object that entices viewers to sit spellbound
in front of it for hours, much less return to see it again and
again. That's because it takes a while before you can even
begin to comprehend the component parts of the KITCHEN

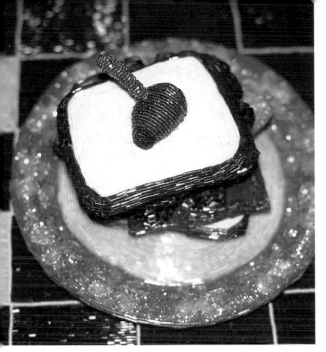

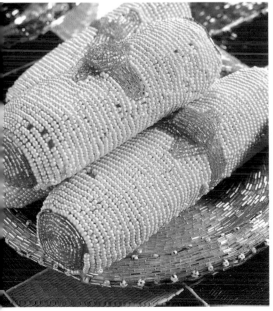

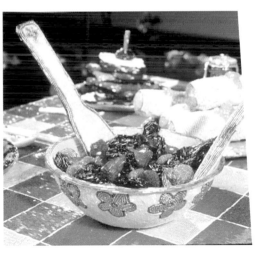

and BACK YARD and to understand how they're made, much less to muse
upon why. Even with that information, it's hard to resist going back once
more for the sheer pleasure of looking further into their glittering
kaleidoscopic depths.

Ultimately, of course, all that labor is only the means to an end, that being

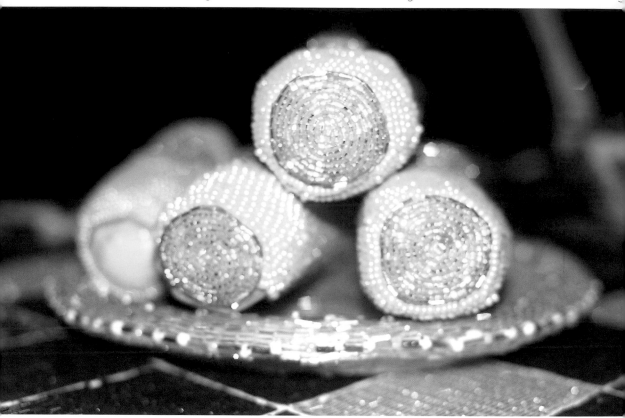

both an appreciation and critical reading of women's work, o
popular culture, of American class-based mores, of artmaking itself
and of the relationship of art to the everyday world.

It's a commonplace that we need to look to the past in order to understand
the present. Liza Lou's work relates to an earlier time, not just to the

1950s, with its fantasy of genteel and appropriately gendered realms of activity, but her use c
familiar craft and vernacular conventions refers specifically to the late nineteenth century
when the Arts and Crafts movement represented American society's struggle to create
appropriate conventions and symbolic forms for modern experience as well to recognize and
understand its past forms.[3] It's hardly surprising that a century later, at the end of the
millennium, Liza Lou and other artists are once again turning to older idioms in order to
understand and grapple with the complex technologies of the future which have already
changed the nature of social interaction.

The KITCHEN and BACK YARD are, obviously, an interior and an exterior, the quintessential
public and private emblems of middle-class life in the United States. Liza Lou both tames the
forces of nature for us (encapsulating them in the perfect backyard), and liberates us from
the constraints of civilization (represented by the ever-sparkling, ever-perfect kitchen). By
embellishing and romanticizing the ordinary, Lou holds these icons up to scrutiny. What is
their real value? What is their ultimate cost? Who is inside, and who remains outside their
parameters, both literally and figuratively?

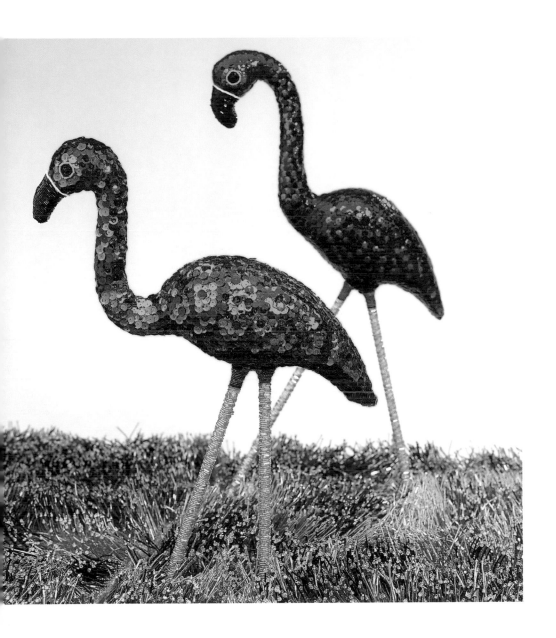

Bead by bead, Liza Lou's Herculean effort to remake a commonplace environment into a wildly colorful, intensely particulate, and detailed work of art has both the immediacy of Disneyland and the "long ago and faraway" quality of the fairy tale, itself an inversion of the quotidian. Liza Lou's work, however, is the Brothers Grimm as retold by Angela Carter, the late British writer who reshaped such traditional tales into glittering, seductively meaningful, and subversive feminist parables. In Liza Lou's hands, as in Carter's, not only the ordinary but even the metamorphosis of the ordinary is yet again transformed, remade into a source of intervention and invention. The KITCHEN and the BACK YARD, icons of middle-class activity and ownership, of economic comfort and emotional equilibrium, are both familiar and hyperreal. Liza Lou has created a new kind of site for the American Dream, a critical and seductive locus at the far reaches of the imagination. Whether you're an eager participant or a shy voyeur, it's a fabulous place to visit, and one that will leave you with indelible memories.